MARTHA'S VINEYARD

VINEYARD

At Its Best

MARTHA'S

CE

COMMONWEALTH EDITIONS
BEVERLY, MASSACHUSETTS

VINEYARD
At Its Best

PHOTOGRAPHS BY
ANDREW
BORSARI

*The author gratefully acknowledges Michael and Lee Karpa
for their insight on Martha's Vineyard.*

Thanks to Russell Scahill and Heather Wallace for their studio assistance.

*I would also like to express gratitude to my wife Elvira who
accompanied me during my stay on the Vineyard.*

*Thanks also to series editor Perry McIntosh
and series designer Anne Rolland.*

ISBN-13: 978-1-889833-90-3
ISBN-10: 1-889833-90-8

Cover and interior design by Anne Lenihan Rolland

Printed in China

Published by Commonwealth Editions, an imprint of Memoirs Unlimited, Inc.,
266 Cabot Street, Beverly, Massachusetts 01915
Visit us on the Web at www.commonwealtheditions.com

Images from this book are available from the Borsari Gallery, Tuna Wharf,
Rockport, Massachusetts (978-546-9683) or the Borsari Studio, Ipswich,
Massachusetts (978-356-0042).

For further information, visit www.BorsariGallery.com.

Cover photo: Aquinnah light house
Overleaf (title page): Rowing pilot gig, Vineyard Haven
Facing page: Impaciens border at Trinity Park

10 9 8 7 6 5 4 3 2 1

INTRODUCTION

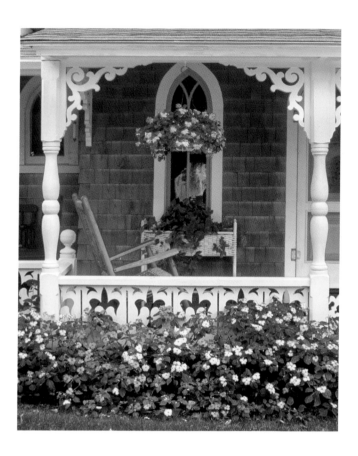

It was with enthusiasm that I accepted the assignment of a photographic essay of Martha's Vineyard. The intent of this book is to celebrate a Vineyard experience. The mood was to be reflective and serene. This book represents seven working days from sun up to sun down following the interplay of island light and sea.

Late summer to early autumn is a time valued by many who love this island—a time for hikers, bikers, sport fishermen and a more private time to be on a pristine beach. It is also a time when the great migration of summer people has abated and the normal rhythms of island life return.

Beyond the scope of this book are many hidden treasures of the Vineyard environment. Land preserves great and small, sanctuaries, and beautiful vistas wait to be discovered. Martha's Vineyard is a special place that deserves admiration.

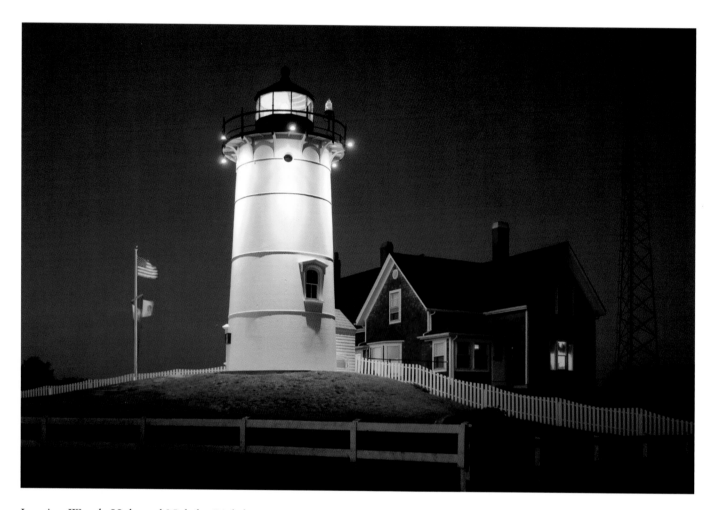

Leaving Woods Hole and Nobska Lighthouse

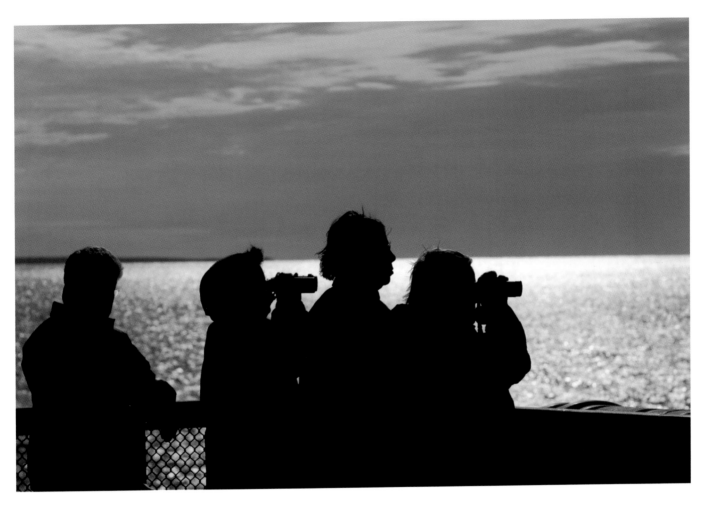

Approaching the Vineyard at dawn on the *Islander*

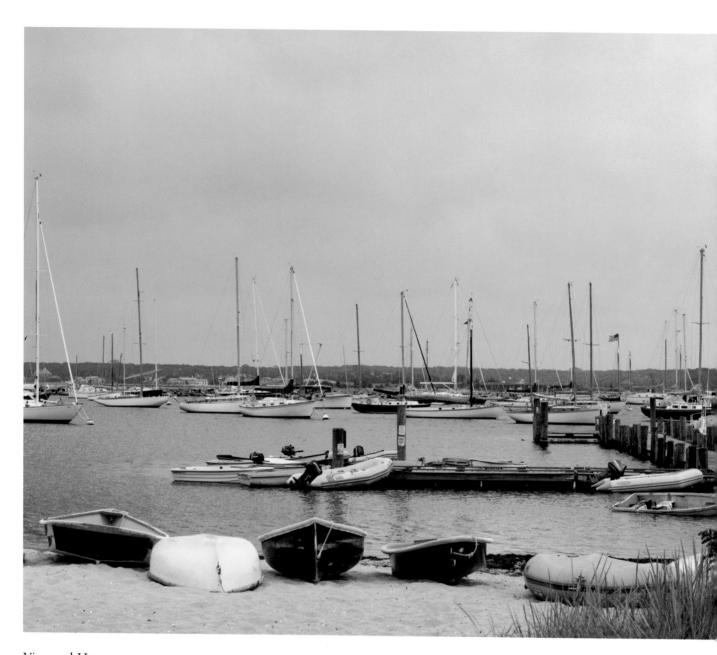

Vineyard Haven

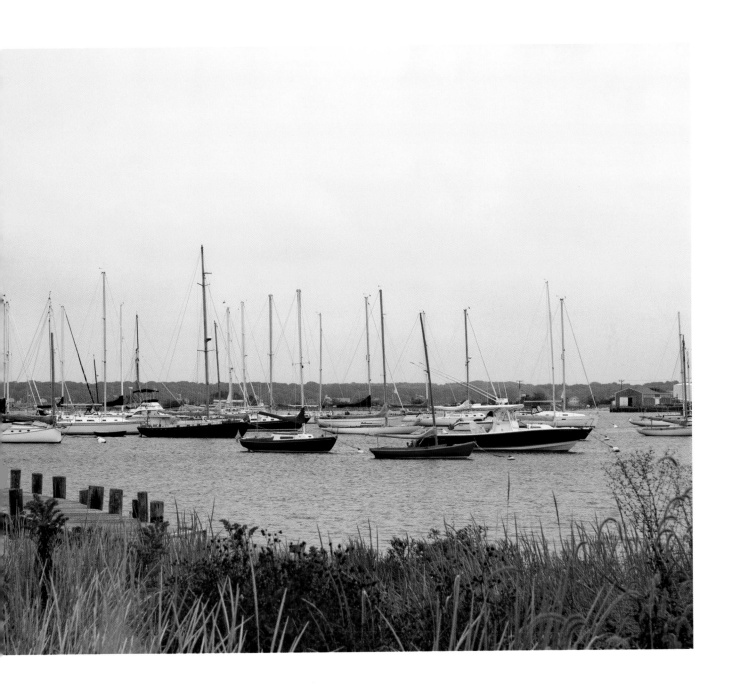

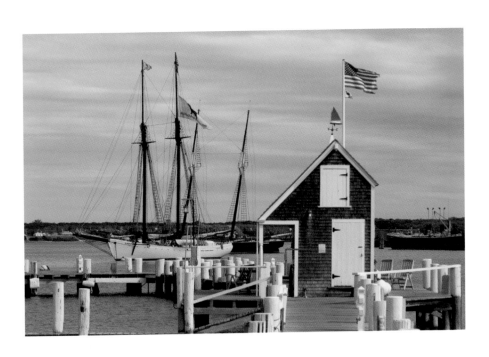

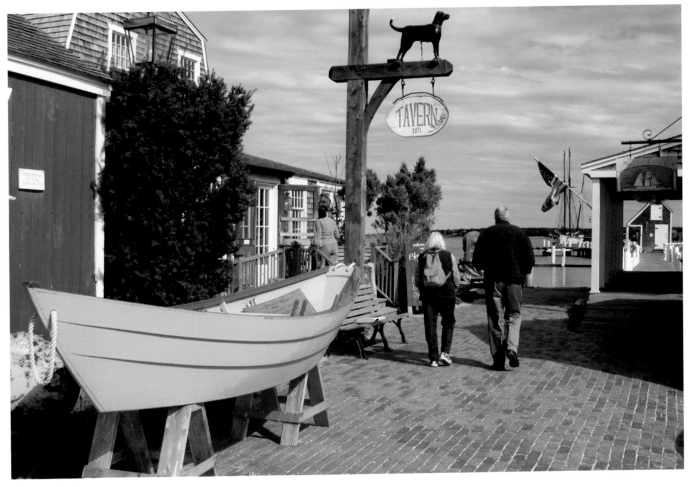

Above: Black Dog Schooner Company, schooners *Alabama* (white hull) and *Shenandoah* (black hull)

Below: Black Dog Tavern

Left: Windswept trees, West Chop, Tisbury

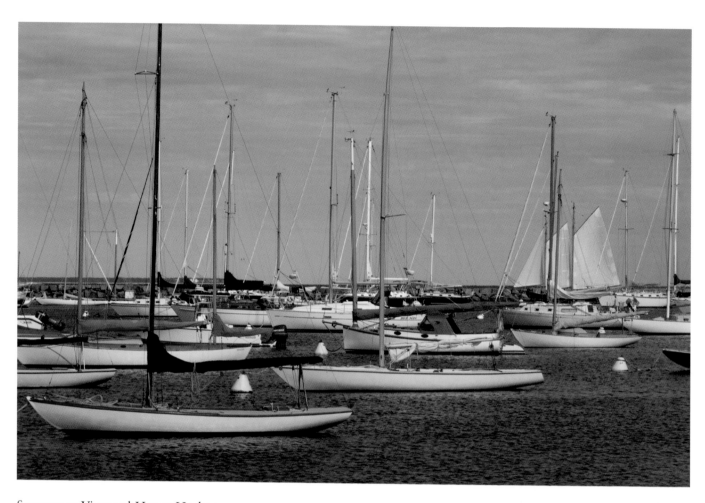

Summer at Vineyard Haven Harbor

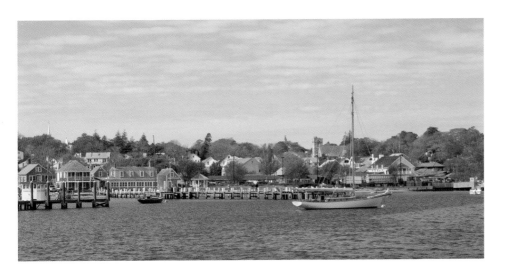

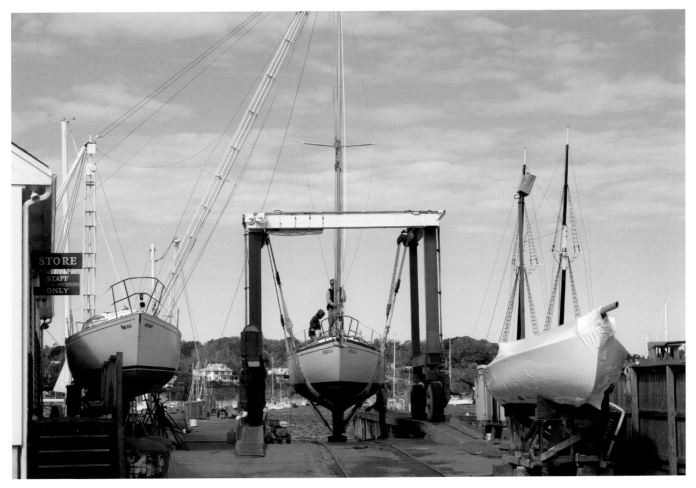

Above: Vineyard Haven waterfront

Below: Boatyard, Vineyard Haven

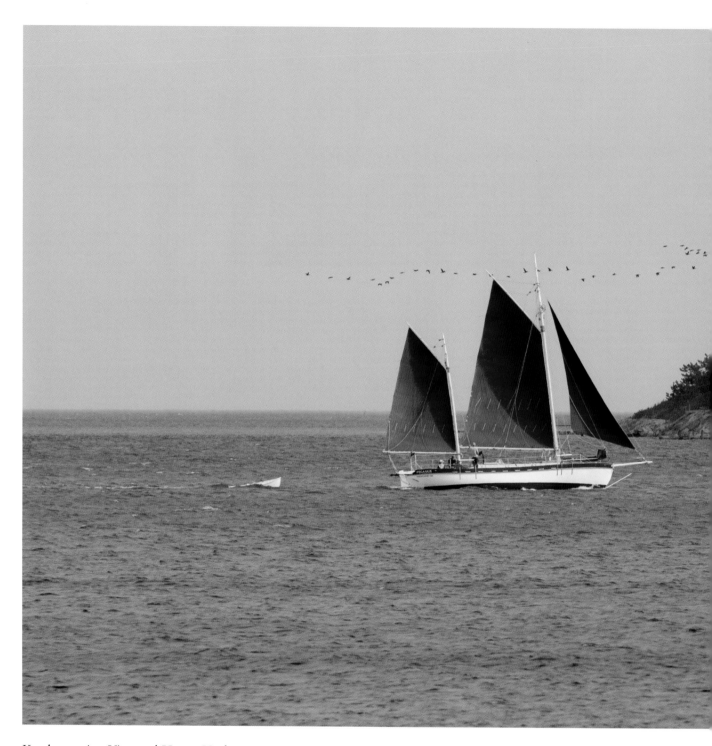

Ketch entering Vineyard Haven Harbor

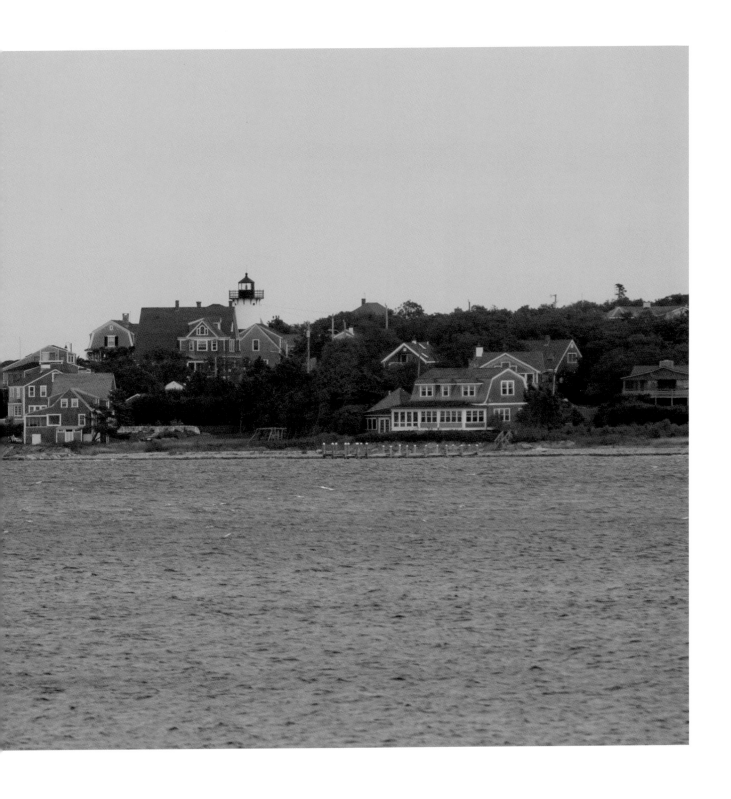

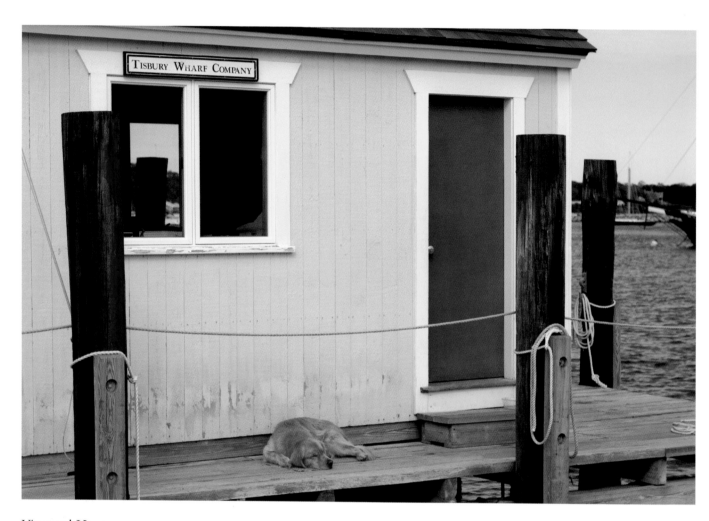

Vineyard Haven

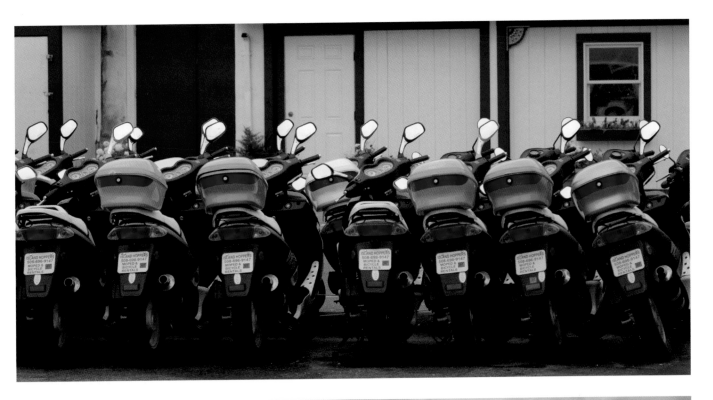

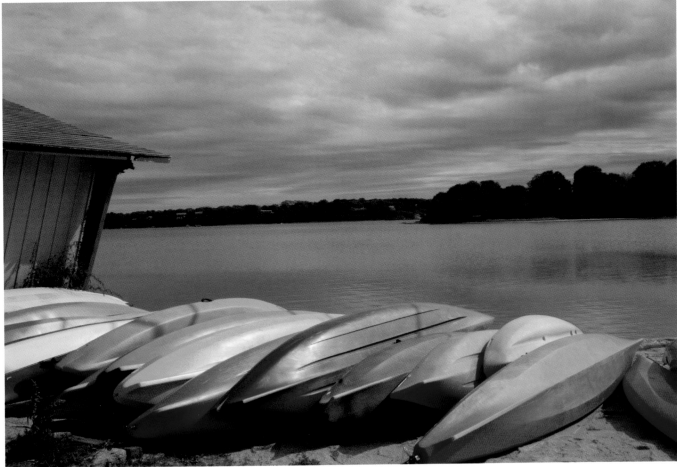

Above: Mopeds at Oak Bluffs

Below: Kayaks by the lagoon in Vineyard Haven

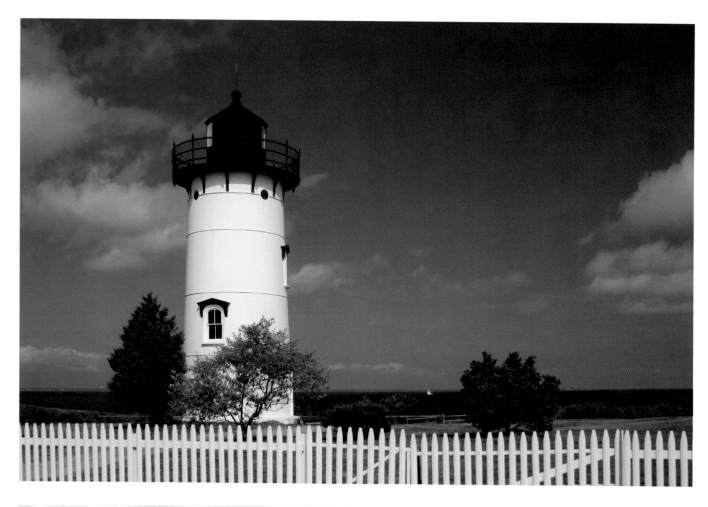

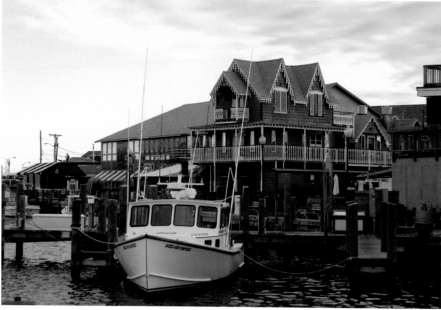

Above: East Chop Lighthouse

Left: Oak Bluffs Harbor

Right: Trinity Methodist Church

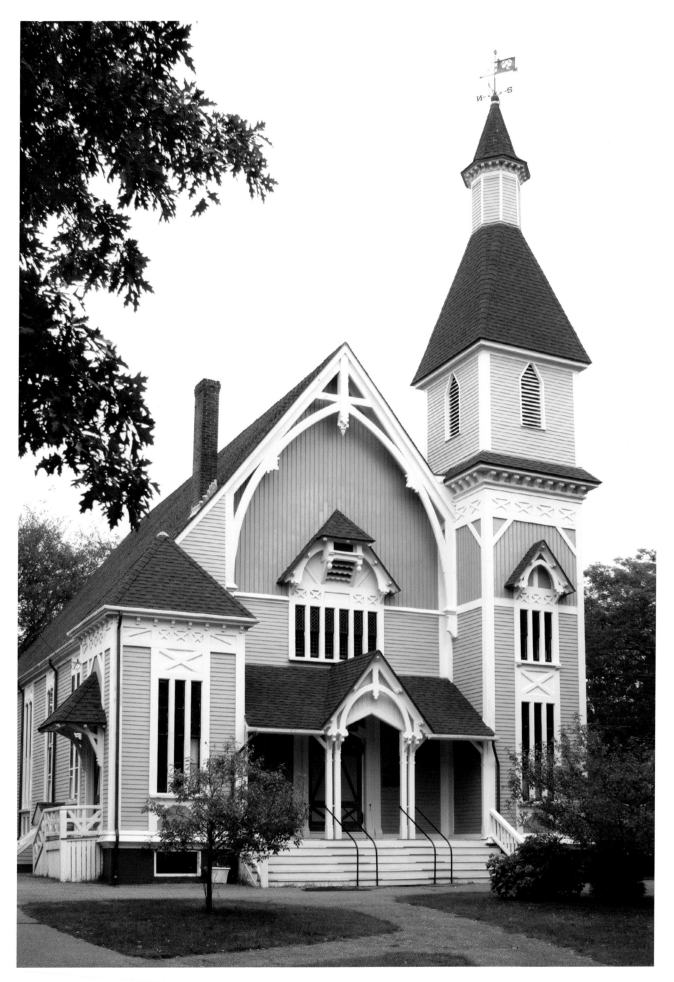

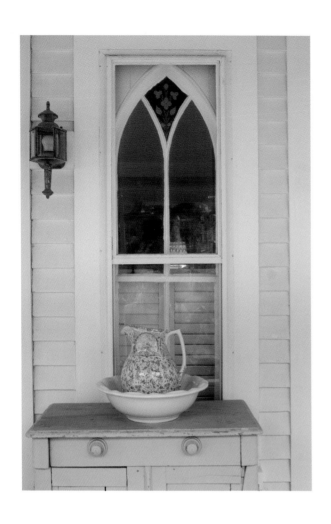

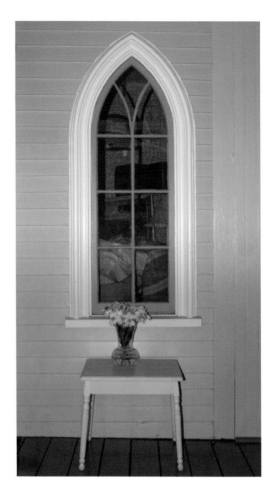

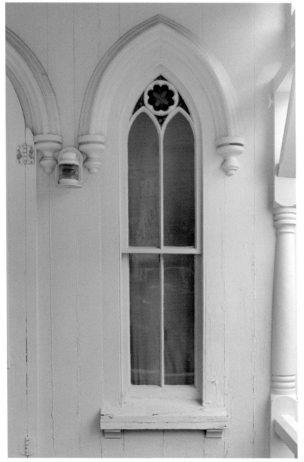

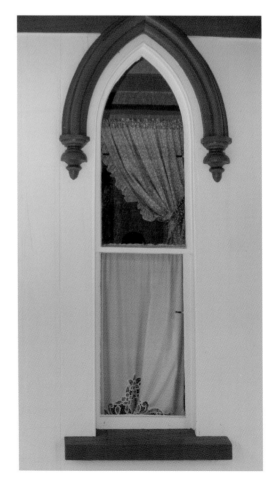

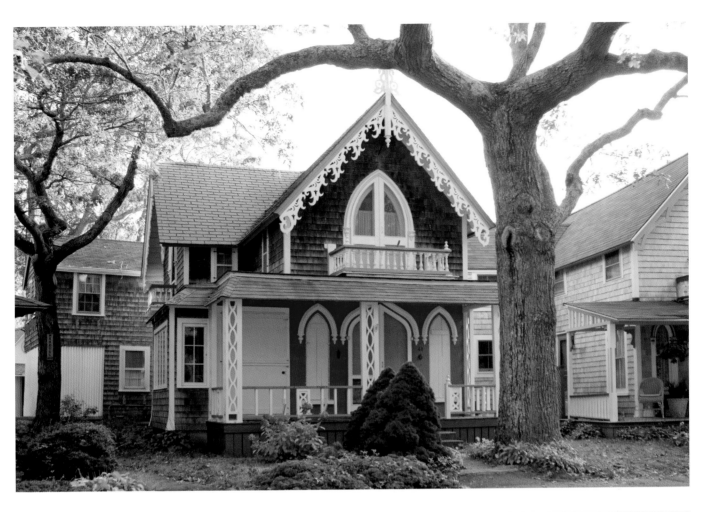

Above, right, and left:
Gingerbread details, Oak Bluffs

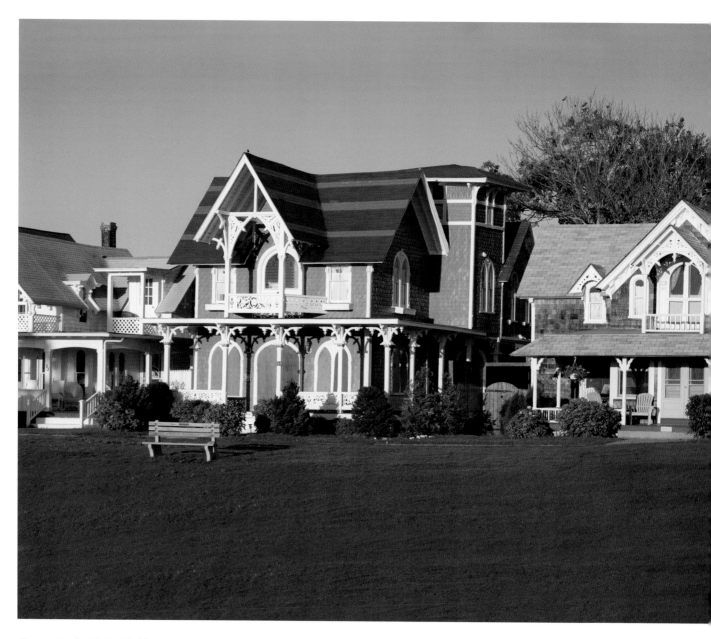

Ocean Park, Oak Bluffs

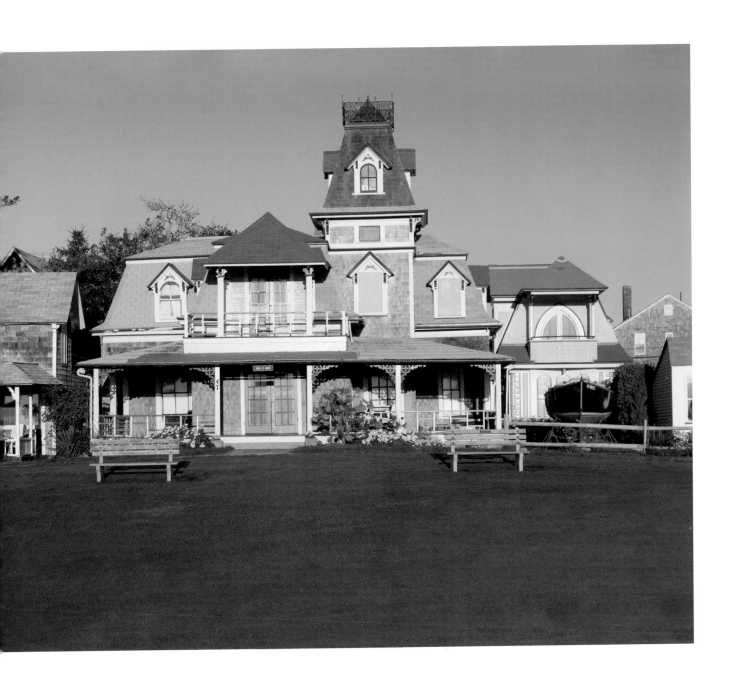

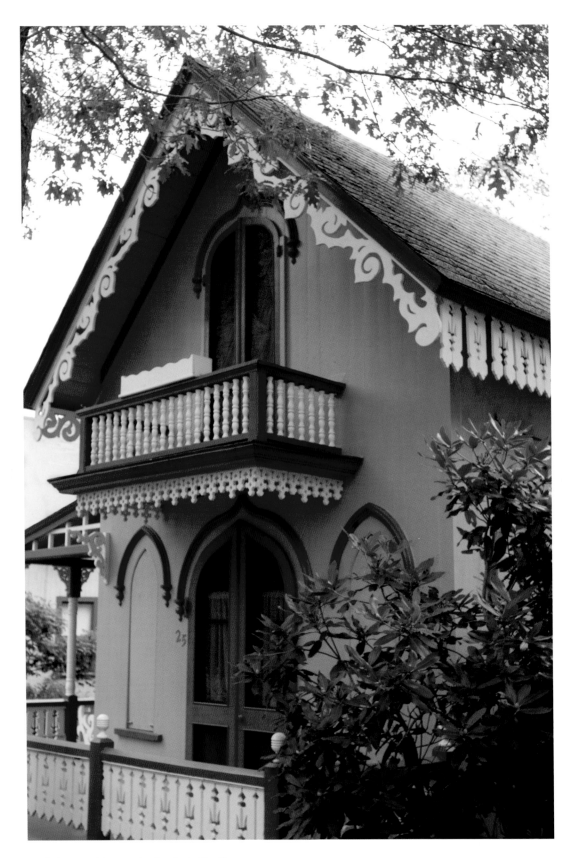

Pink house, Trinity Park, Oak Bluffs

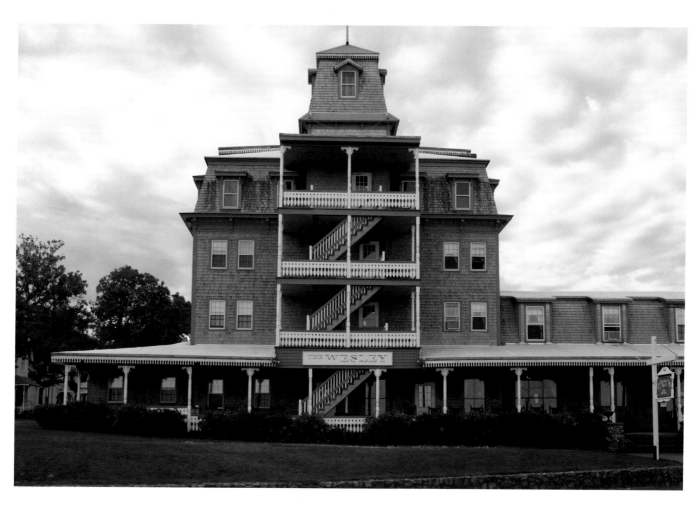

The Wesley, Oak Bluffs

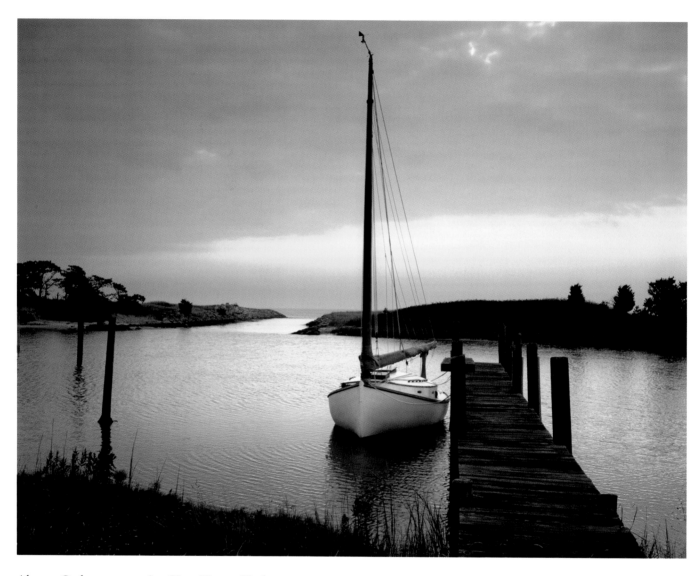

Above: Catboat at sunrise, Hart Haven Harbor

Right: Schooner at sunset, Hart Haven Harbor

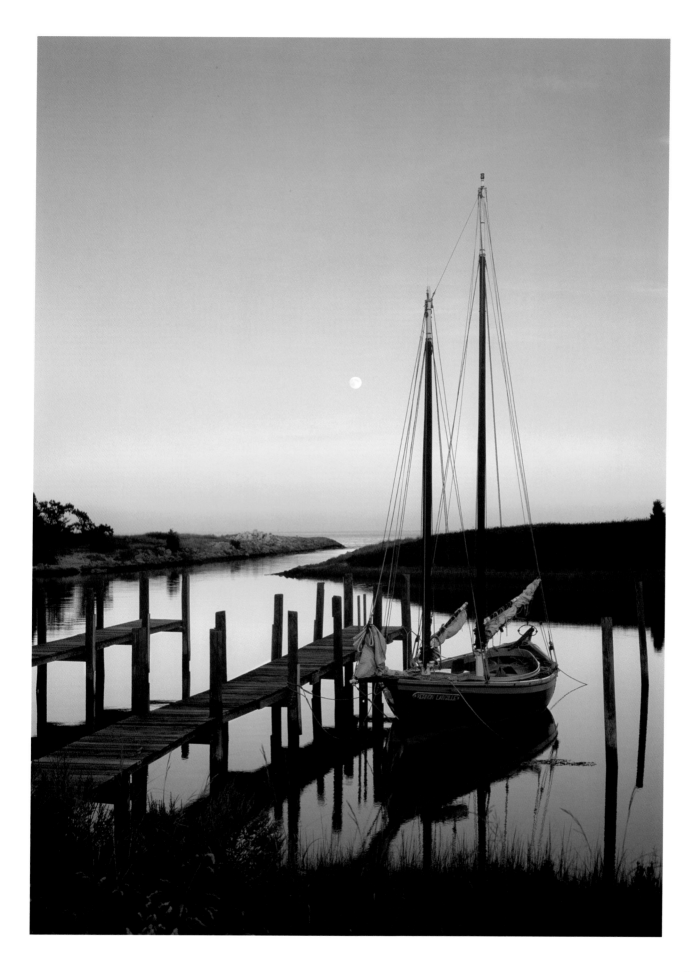

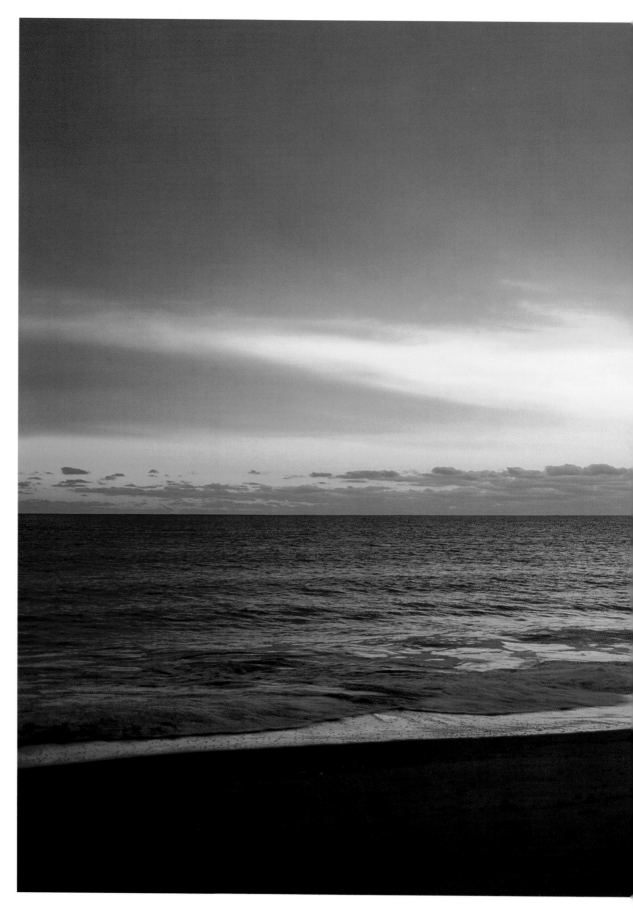

Atlantic sunrise

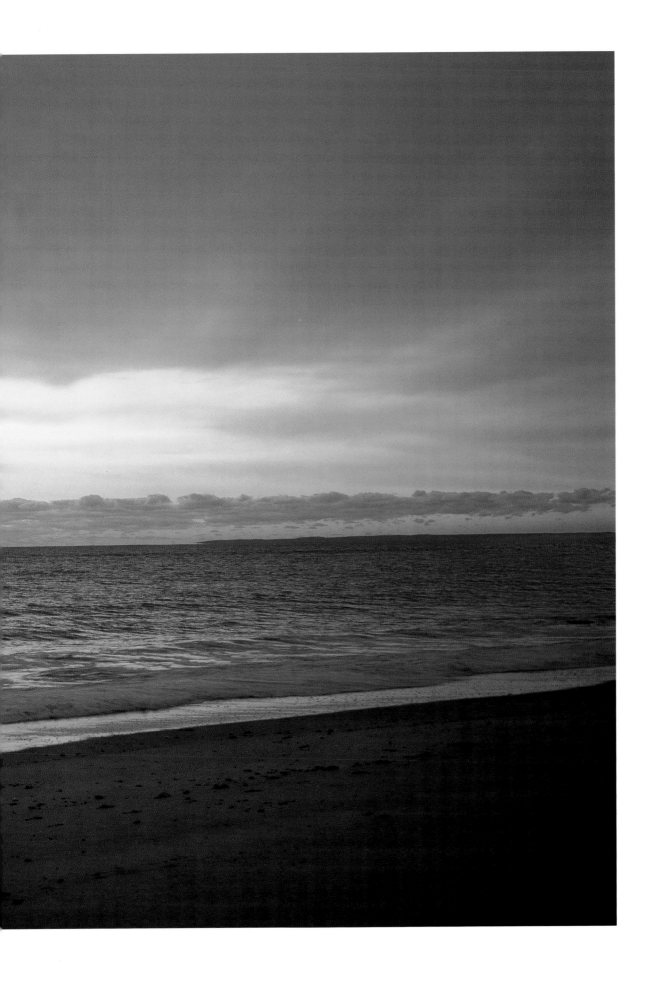

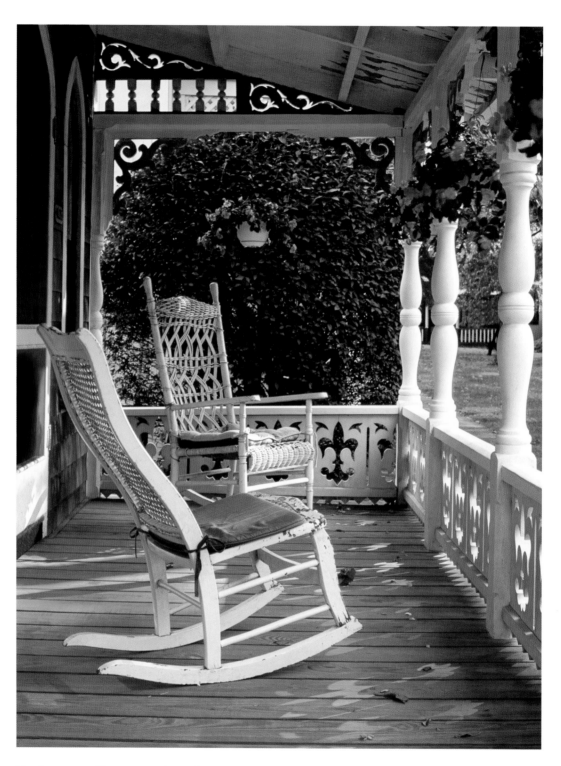

Rockers on a Campground porch

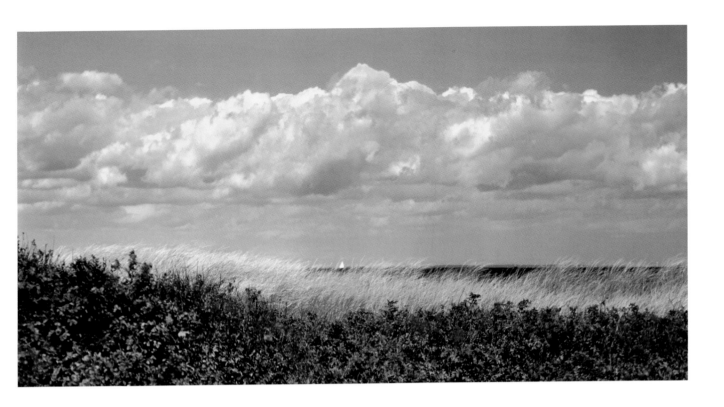

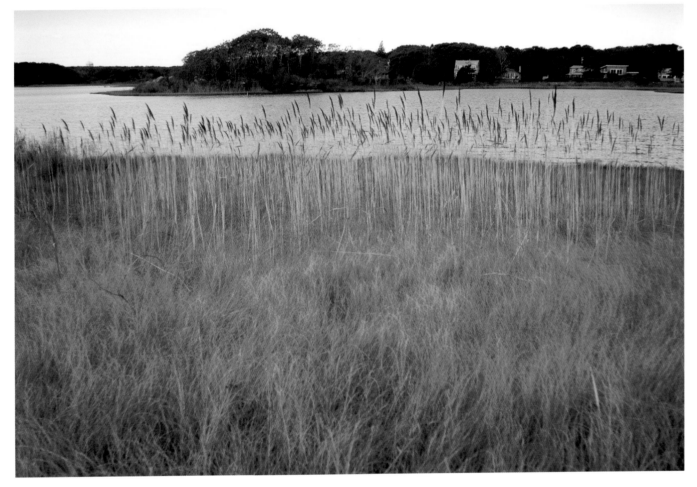

Above: State Beach

Below: Sengekontacket Pond

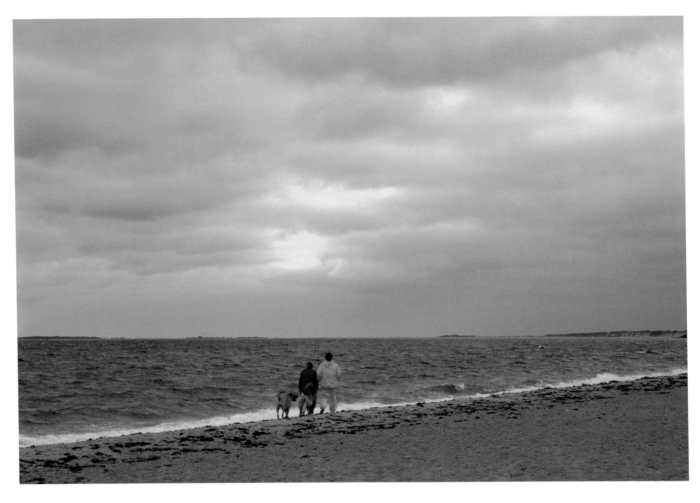

Above: State Beach

Top right: Beach Road, Cow Bay

Bottom right: Beach Road, Trapp's Pond

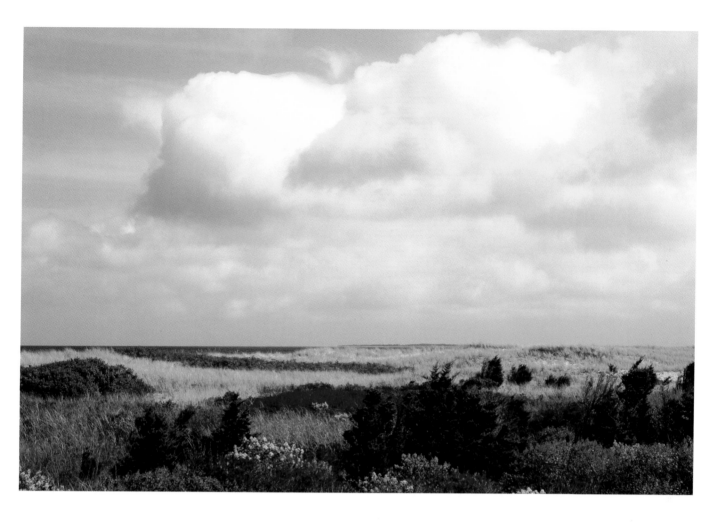

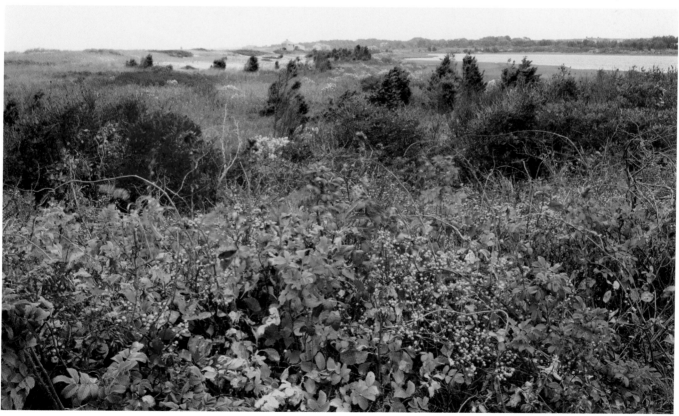

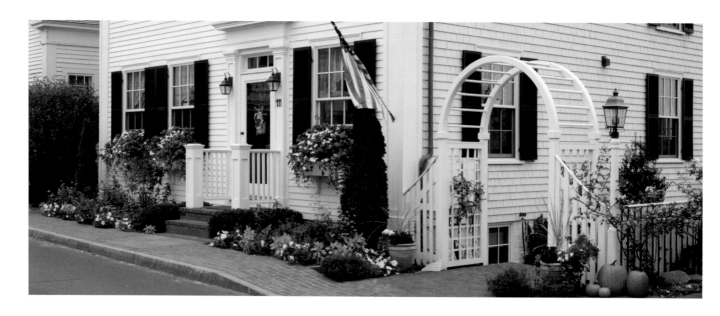

Above: Edgartown

Below: Curves and shingles in Edgartown Harbor

Right: Old Whaling Church, 1843

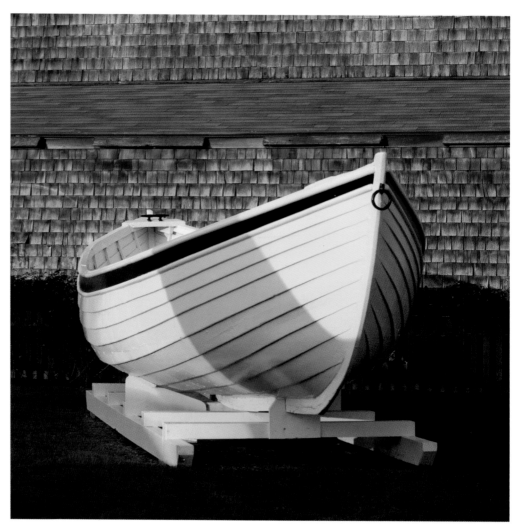

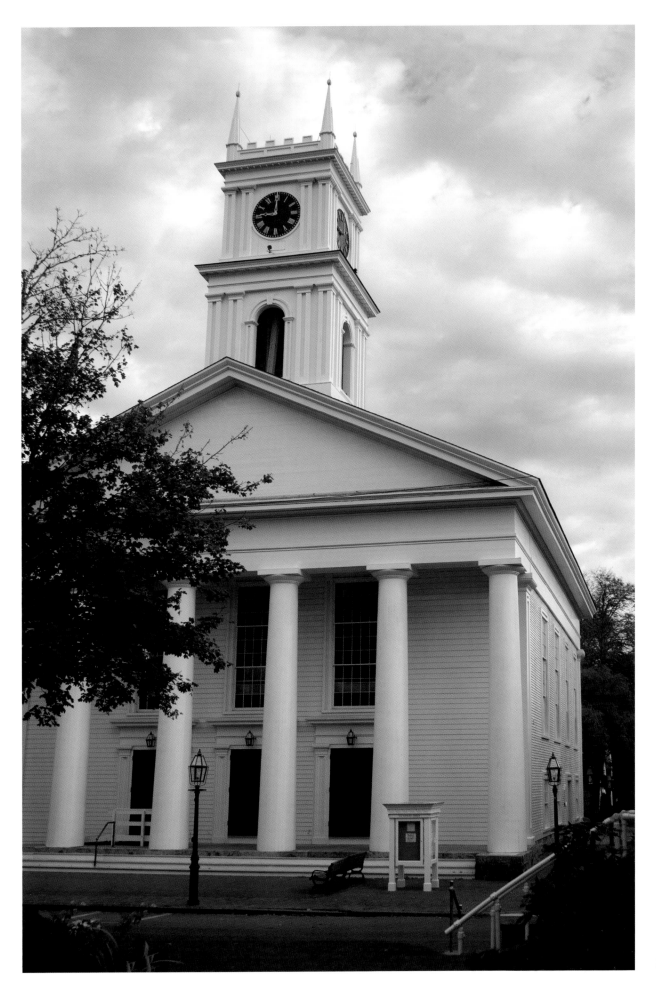

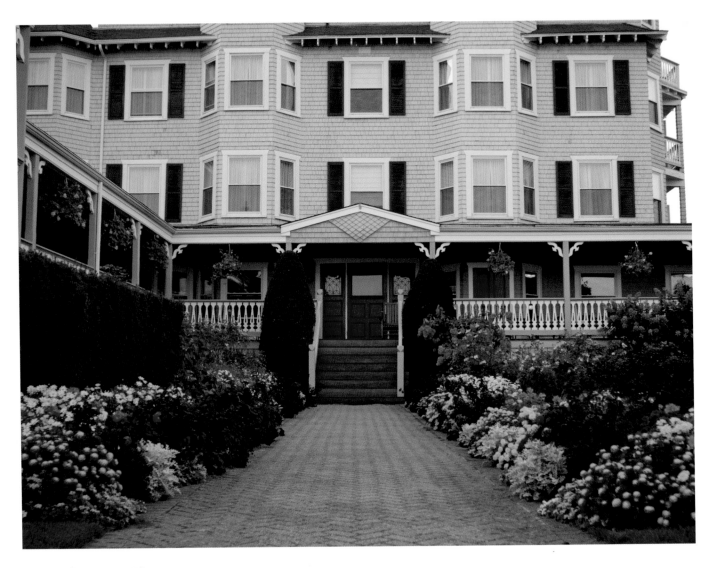

The Harbor View, Edgartown

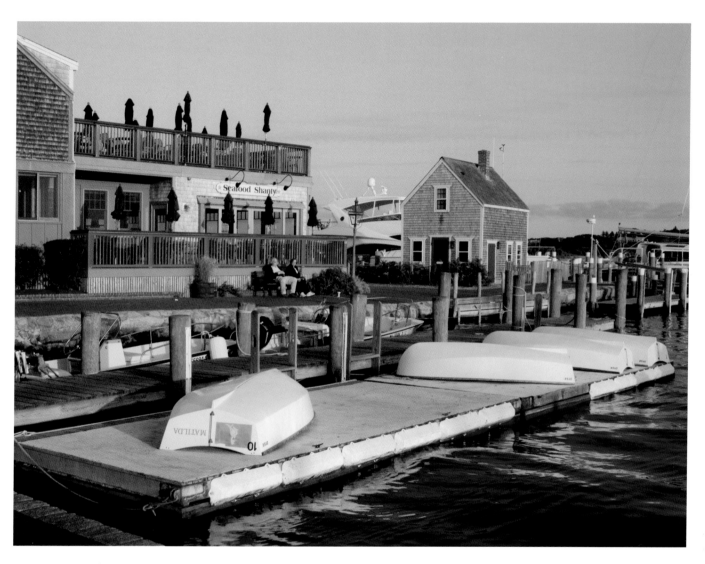

Edgartown Harbor

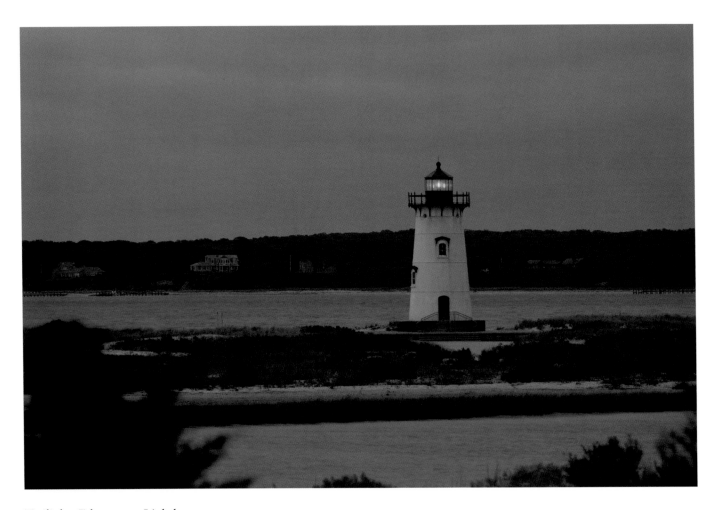

Twilight, Edgartown Lighthouse

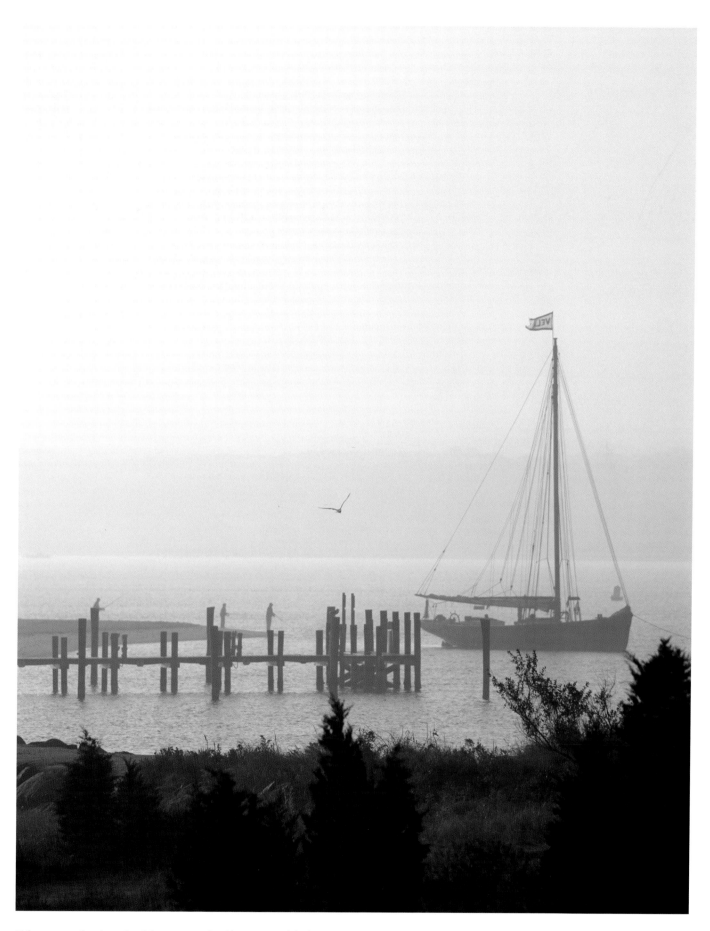

Edgartown harbor, looking towards Chappaquiddick

Right: Tea time on
an Edgartown porch

Below: Edgartown

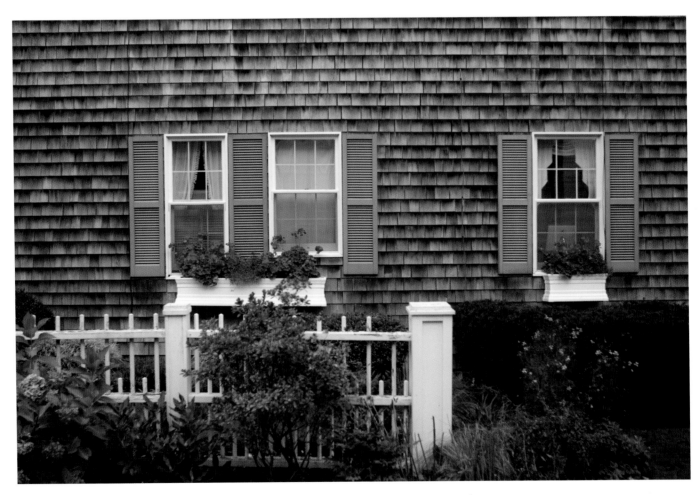

36

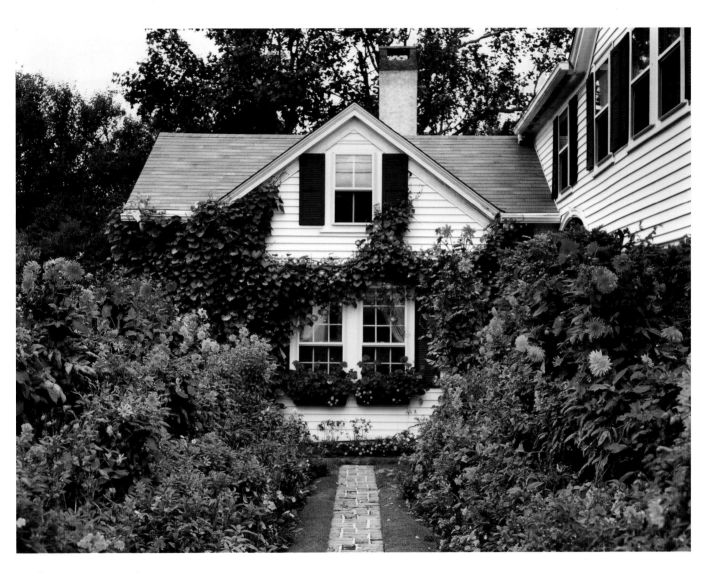

Emily Post House, Edgartown

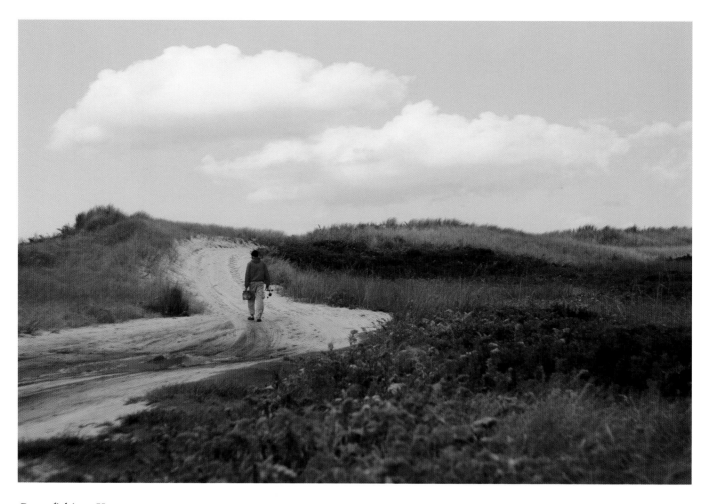

Gone fishing, Katama

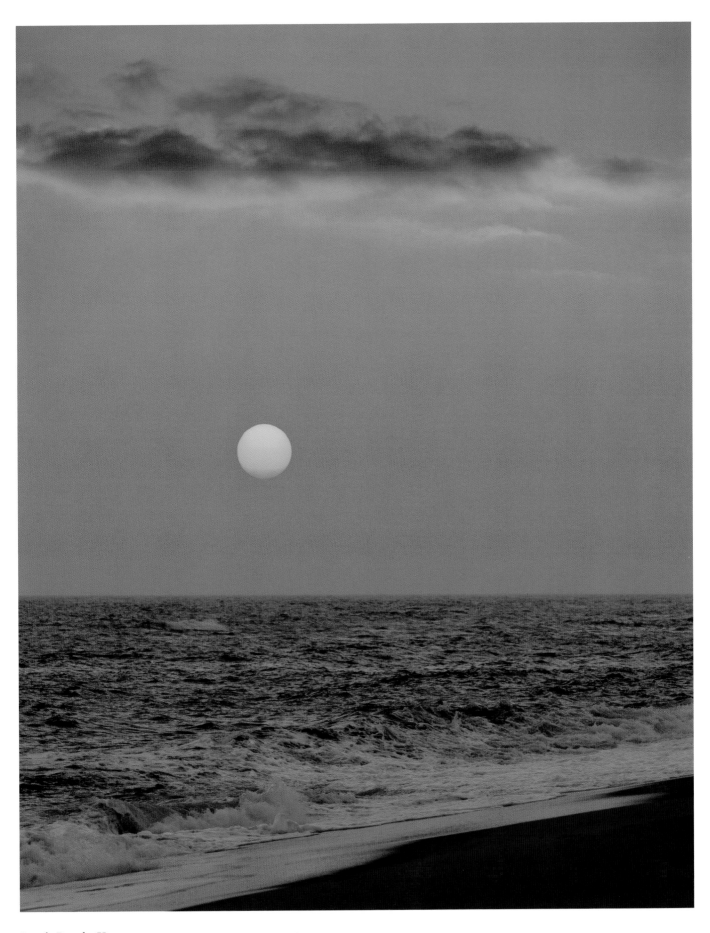

South Beach, Katama

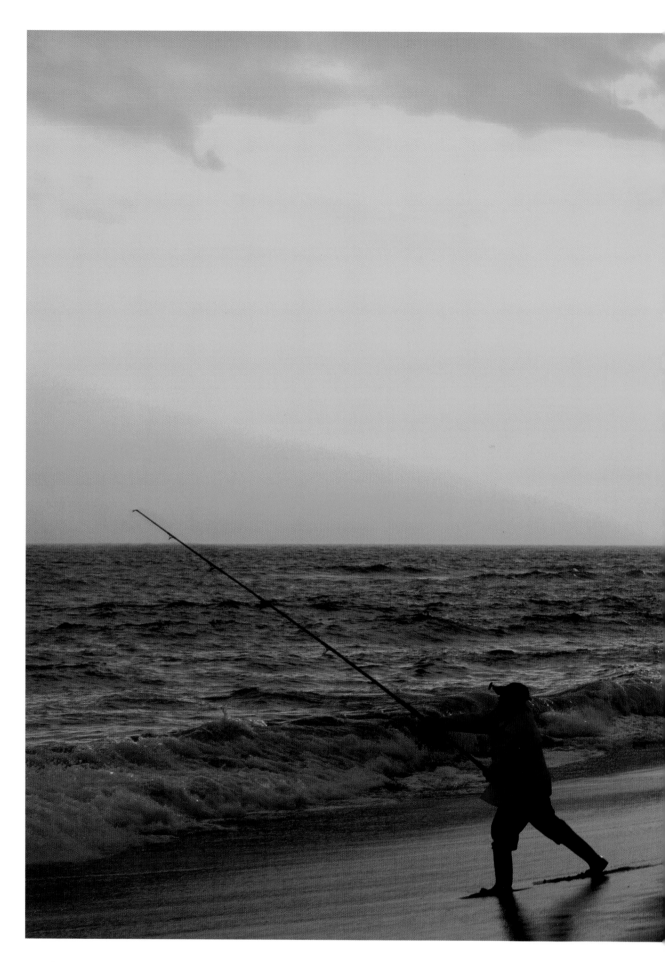

40 South Beach, Katama

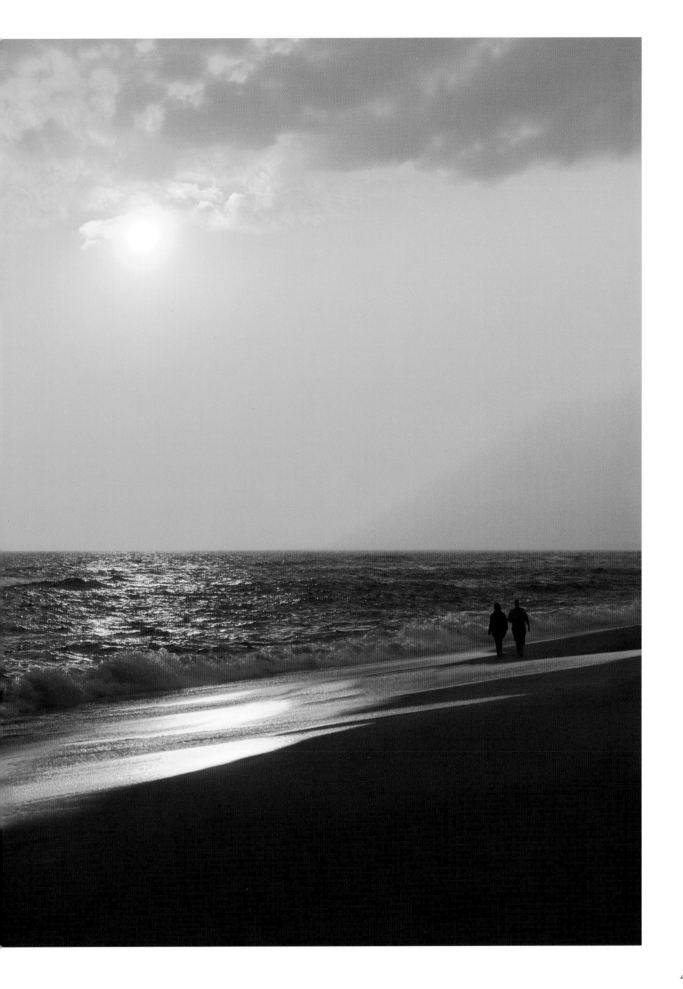

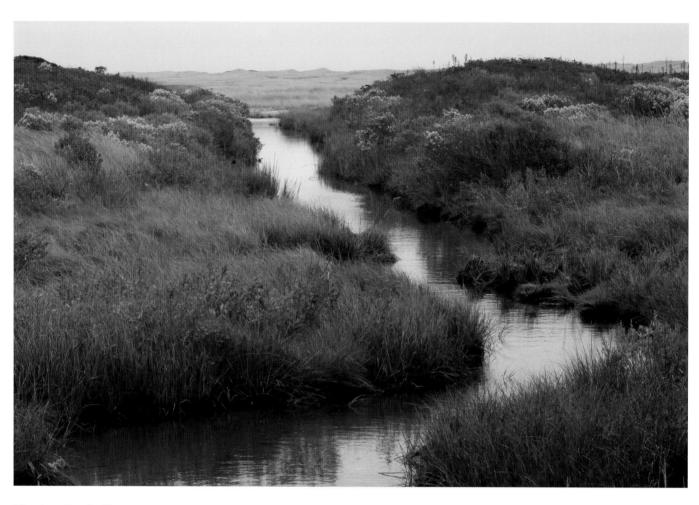

Herring Creek, Katama

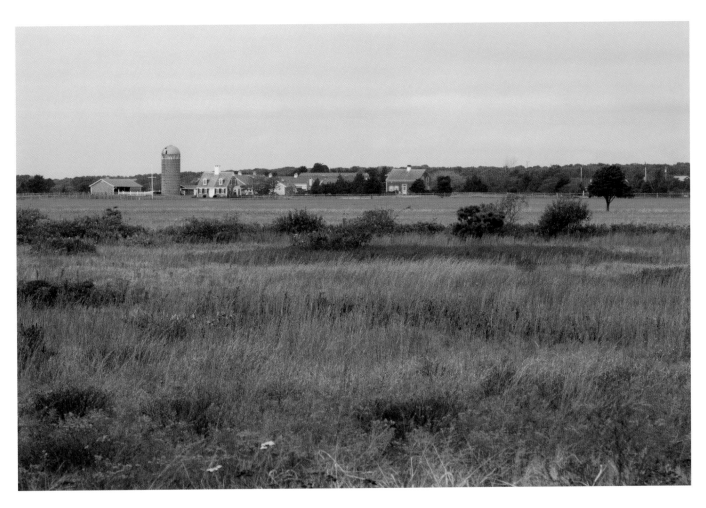

Farming preserve, Herring Creek Road, Katama

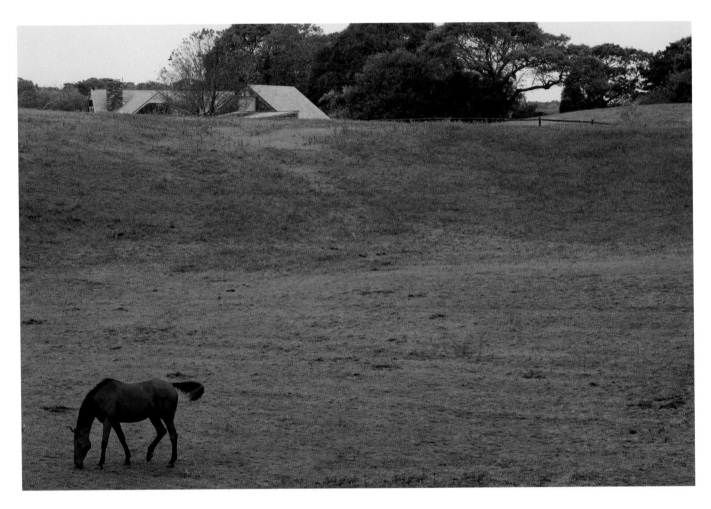

Horse farm, Katama

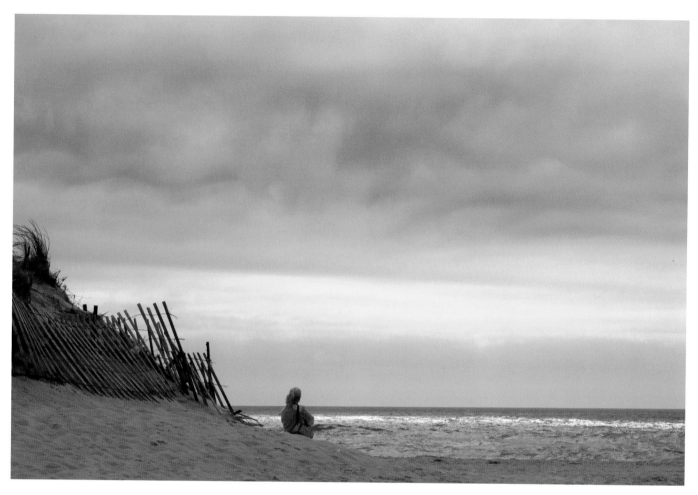

South Beach

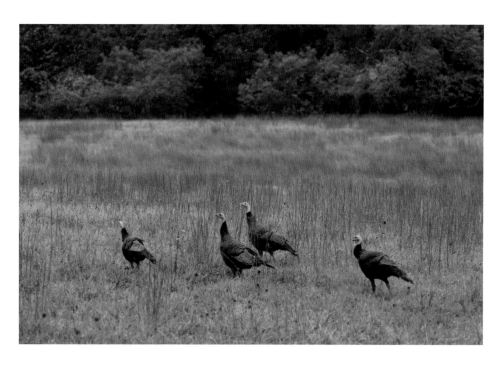

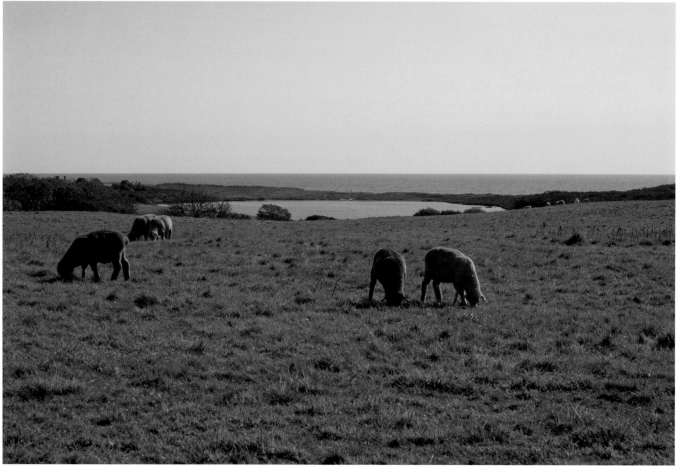

Above: Wild turkeys, Chilmark

Below: Sheep meadow overlooking Chilmark Pond and the Atlantic Ocean

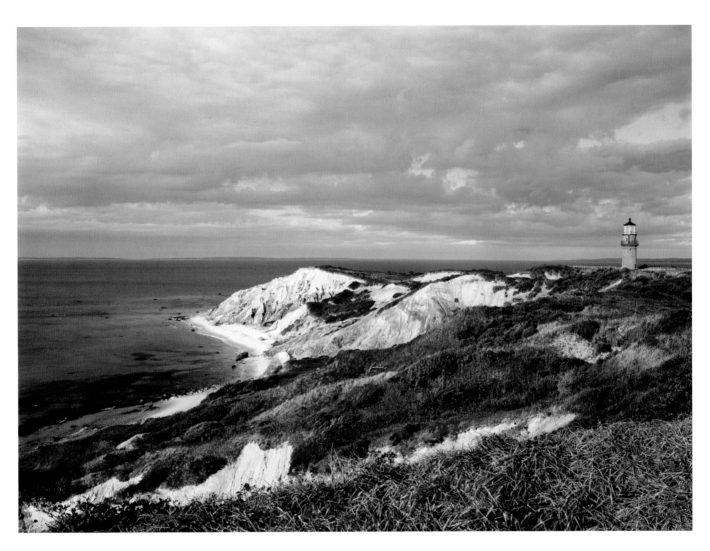

Aquinnah (Gay Head)

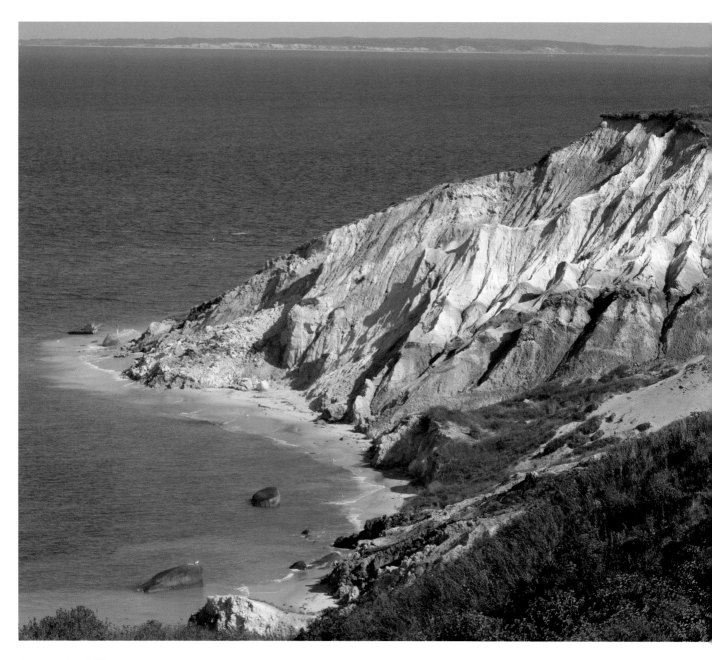

Aquinnah Cliffs

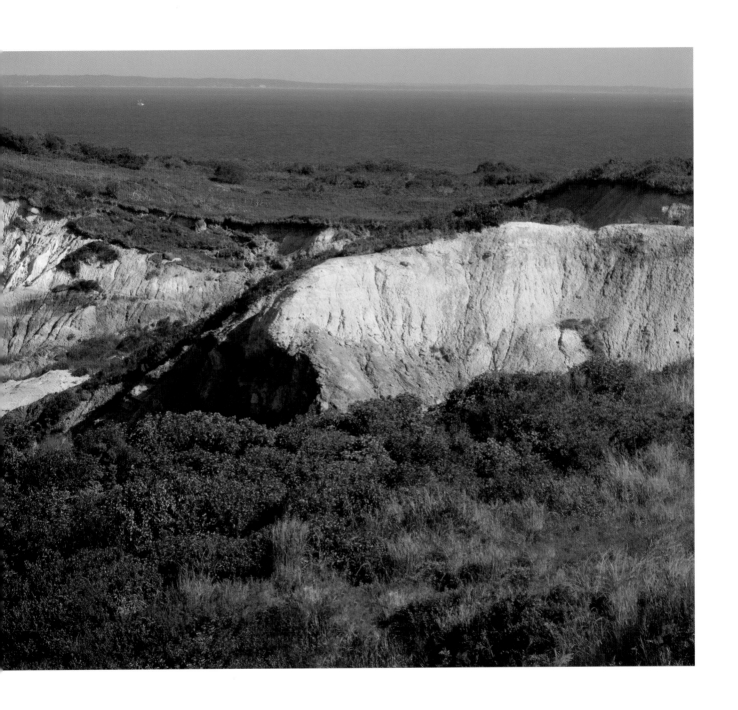

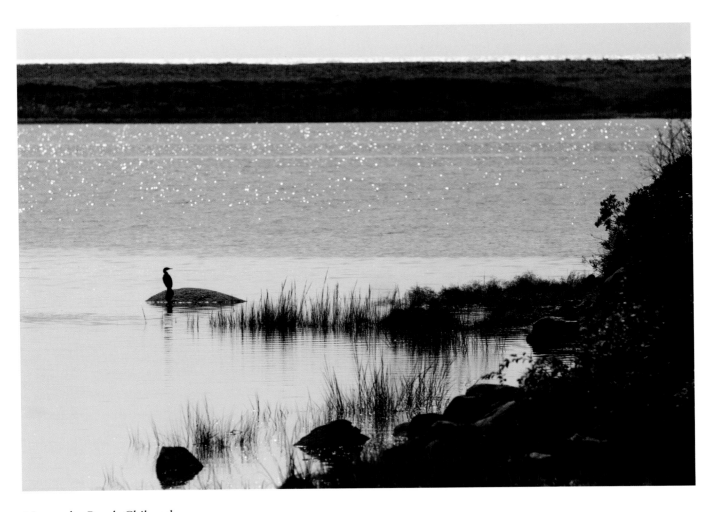

Menemsha Pond, Chilmark

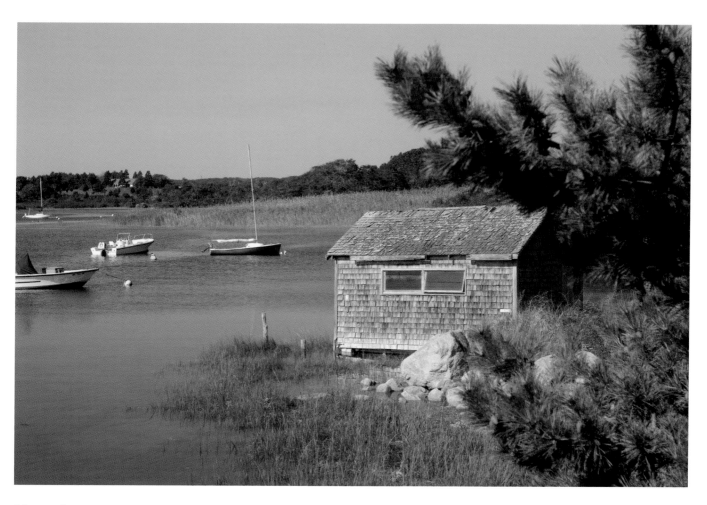

Menemsha

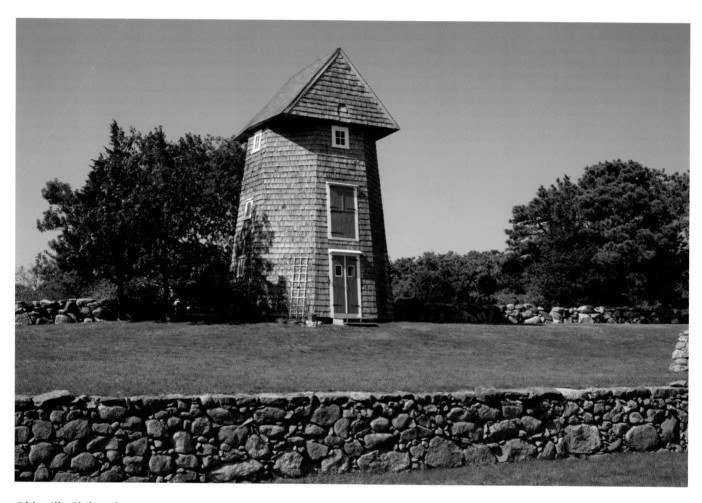

Old mill, Chilmark

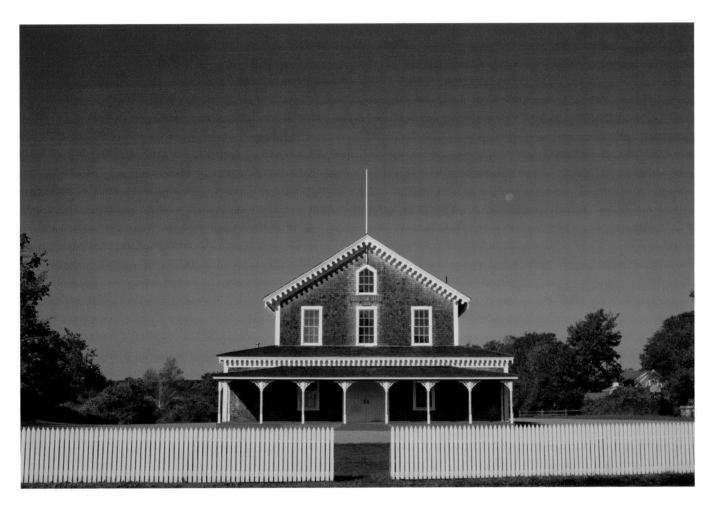

Grange Hall, West Tisbury

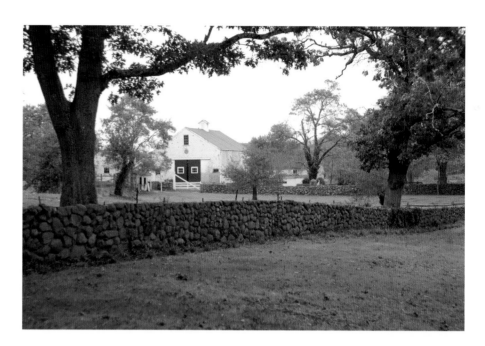

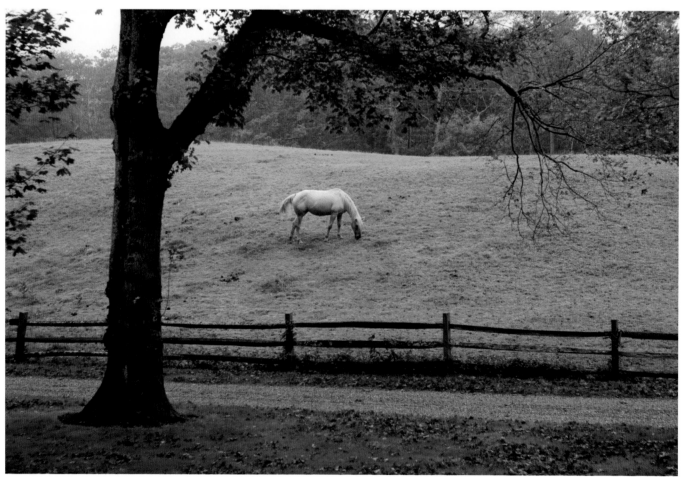

Above: Old stone wall, West Tisbury

Below: West Tisbury

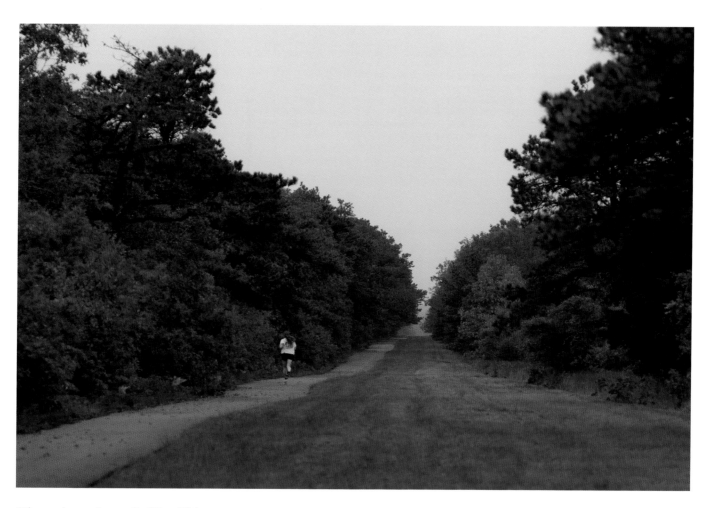

Bike and running trail, West Tisbury

Fog at the Lake Tashmoo overlook, Tisbury

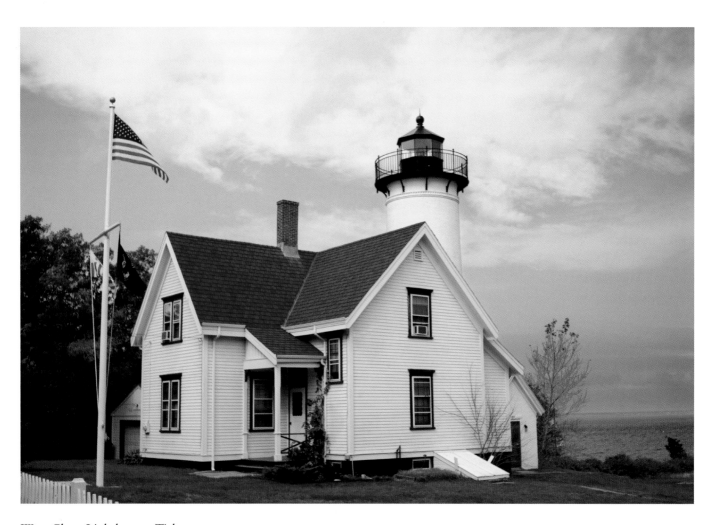

West Chop Lighthouse, Tisbury

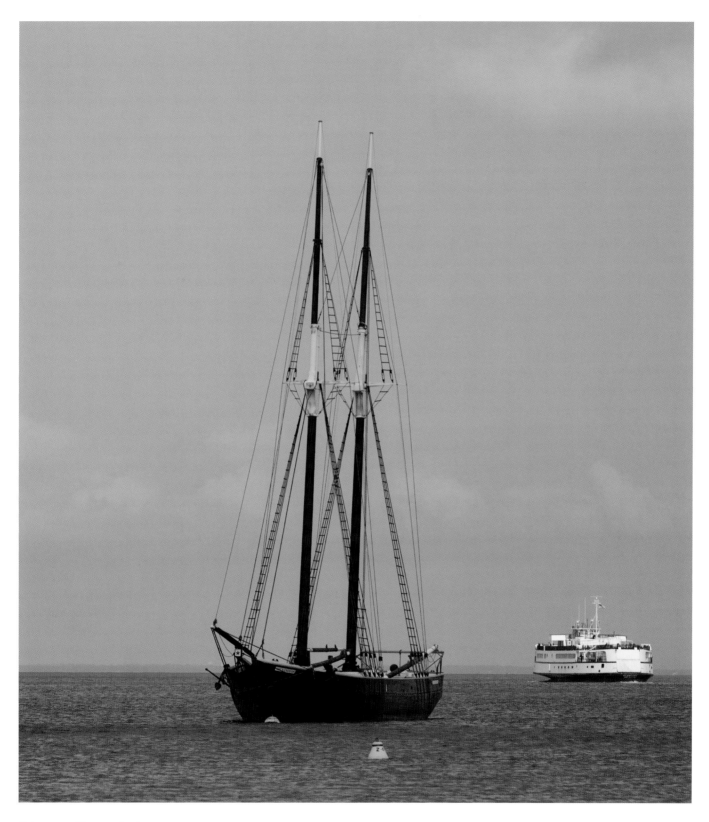

Schooner *Shenandoah*

ANDREW BORSARI

Andrew Borsari is a native New Englander and has been actively involved in photography for over fifty years. Over the past twenty years he has devoted all his energy to personal and commisssioned work that includes fine art, landscape, and still life. His work has been featured on the television series *Chronicle* and magazines such as *Shutterbug* and *Outdoor Photographer*. In addition, UNICEF International has printed his images on greeting cards. Andrew and his wife, Elvira, live in Ipswich, Massachusetts. The Borsari Gallery is located on Tuna Wharf in Rockport, Massachusetts. Images from his gallery have gone out to corporate and private collectors in over 30 countries. This is his fifth book for Commonwealth Editions.